Divertissement

Divertissement
...I Dreamed a Dream

CLAIRE YAFFA

RUDER FINN PRESS

Editorial Director: Susan Slack
Creative Director: Lisa Gabbay
Art Director: Sal Catania
Design Director: Emily Korsmo, Ruder Finn Design
Production Director: Valerie Thompson
Pre-Press: Steve Moss

ISBN-10: 1-932646-47-7
ISBN-13: 978-1-932646-47-4

PRINTED IN CHINA

For my husband
who dreamed a dream
with me

Pascal stated, "all human beings seek diversion because they can't bear to be alone with themselves…introspection the single most painful thing in life…seeing the nullity of one's own condition with the certainty that one is going to die. The simple basic fact of life, that no human being can live without desperate measure to ward off our own undoing, which is guaranteed." The fear and idea of death results in human activity helping to deny thoughts of the final destiny for man. Our mortality is not often questioned in daily life and we immerse ourselves in its details to avoid thinking of the inevitable future. We postpone and deny its existence by the many things that fill ourselves and our life.

Introduction

Divertissement is about loss, but it is also about cherished moments of living. The subtleties of our everyday existence may not always be recognized, but sometimes we are awakened by what we are seeing and feeling. The photographs in *Divertissement* spoke to me and happened because I saw them—and they touched me in some way.

Upon seeing a beautiful red cardinal outside my window, I said, "how beautiful!" Looking beyond that bird, I saw another, just as beautiful, but in an instant, he was stilled forever. He had flown into the glass of the closed window. I watched as the beautiful red bird tried to understand what had happened. The bird frantically ran around the dead bird. He would come close to him, but when he saw me, he would fly away. He returned again and again trying to prod the bird to wakefulness, to restore him to life. Finally he flew away, and left me to imagine the memories he took with him and the reality of his loss.

The red cardinals have become a metaphor for me. Whenever we lose what it is we cherish, it becomes a part of ourselves. Enriched by our experiences of those we have loved and those we have lost, we continue. As long as we live, they will always be a part of us. We honor and remember them, and share the love they gave to us with others, because they have shown us the way.

CKY
June 2008

Divertissement

I dreamed a dream

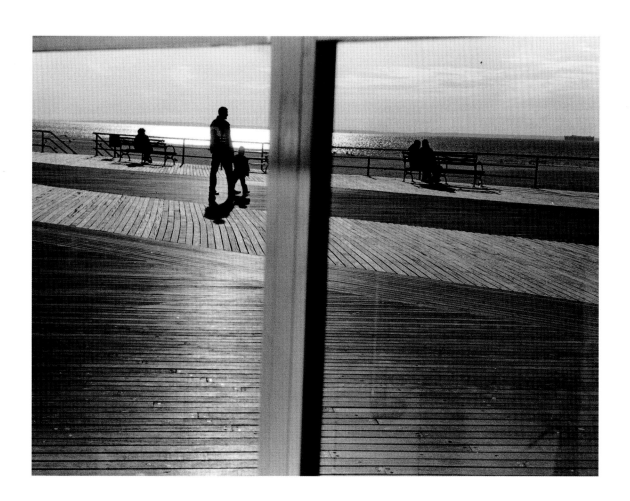

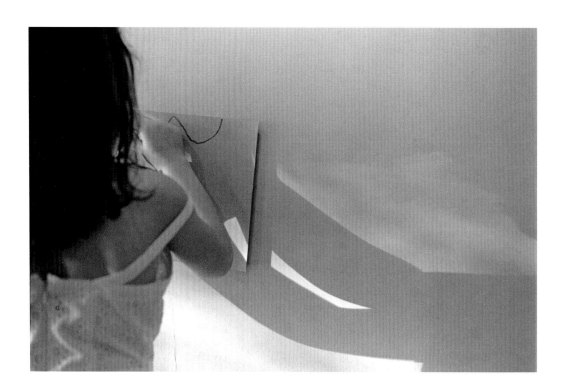

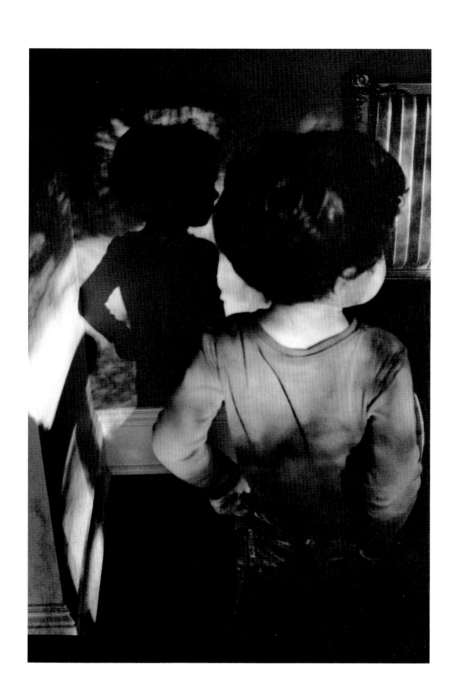

Two rings
Fell from my hands

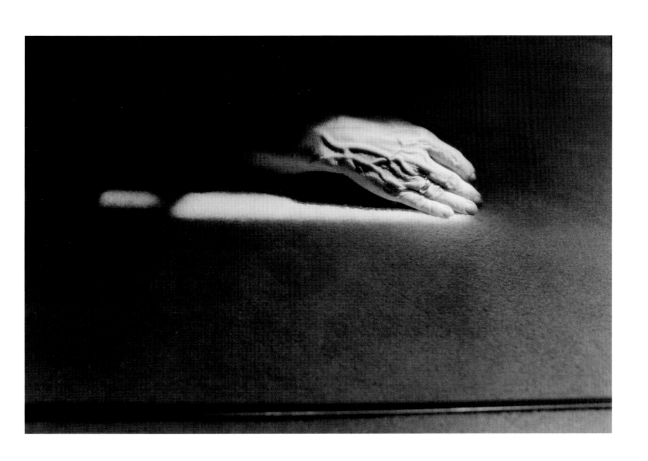

Breaking apart
Gathering pieces
To be together again

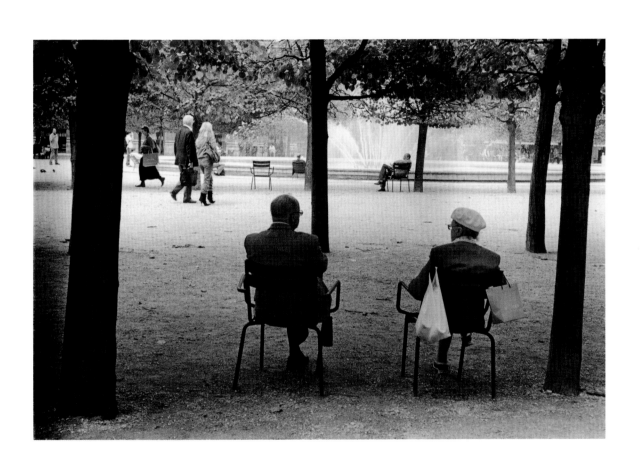

I dreamed a dream

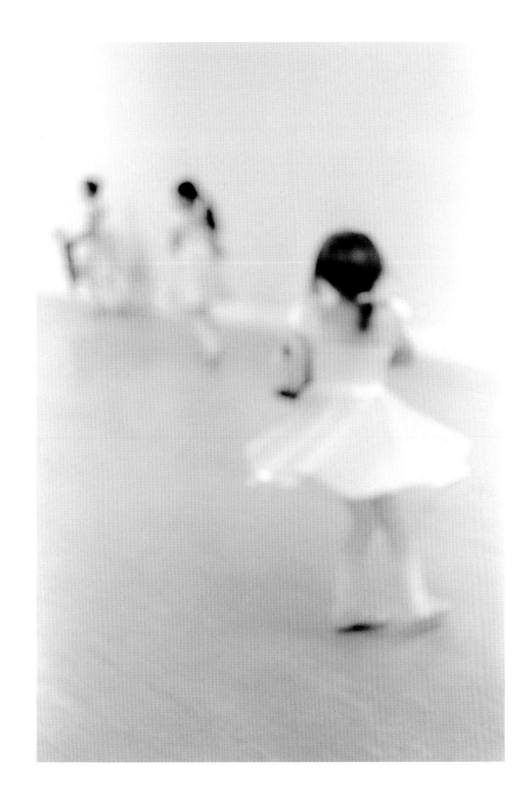

I saw the moon
The moon saw me

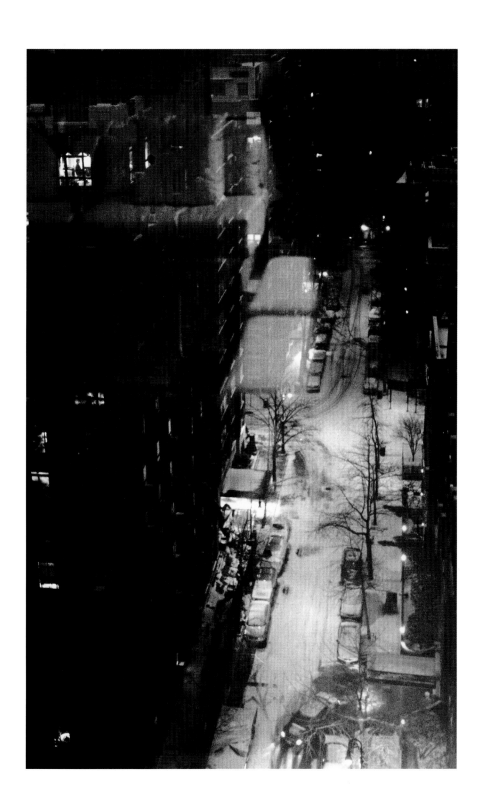

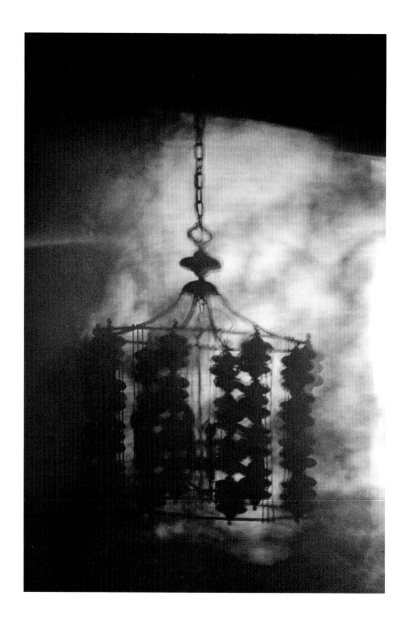

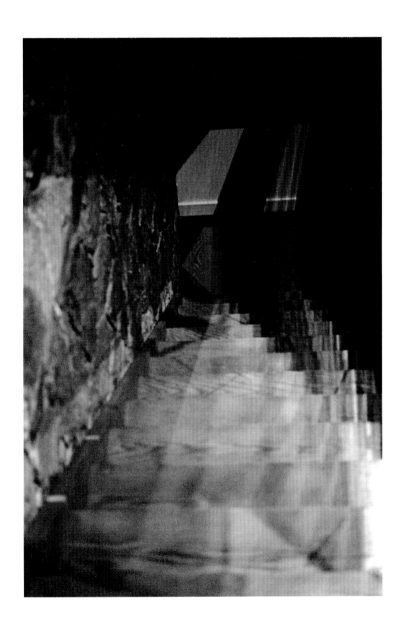

I made a wish on the moon

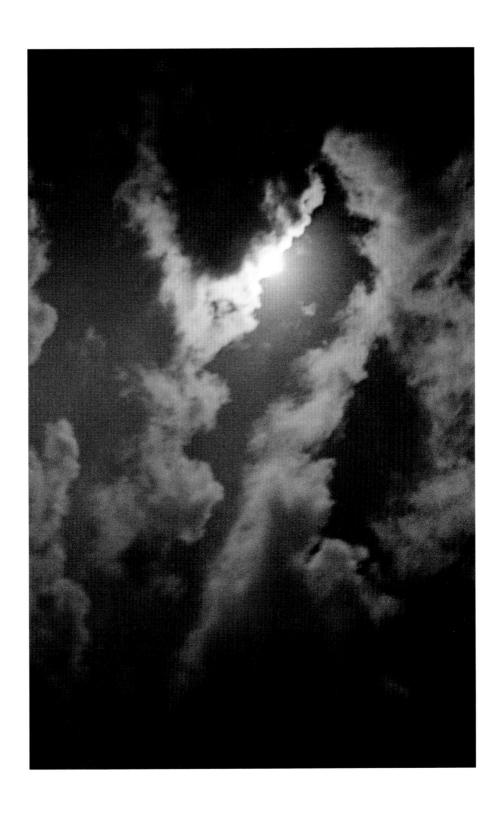

I closed my eyes
I disappeared with the moon
Behind the clouds

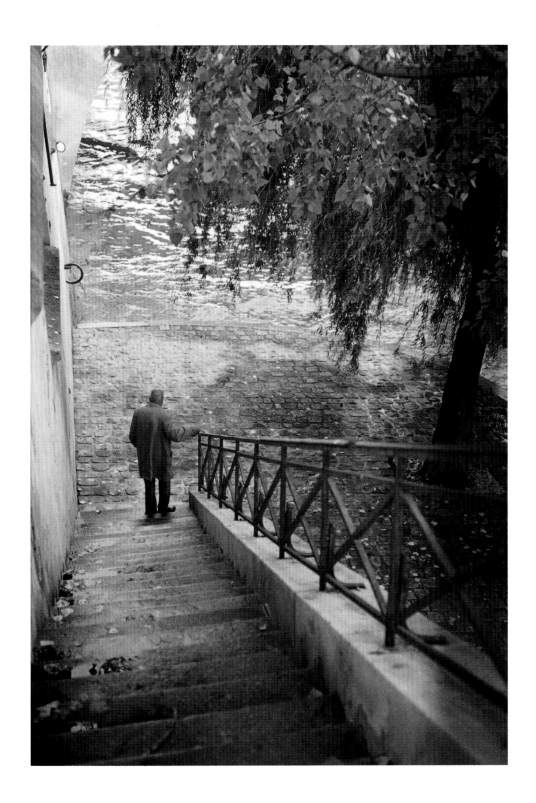

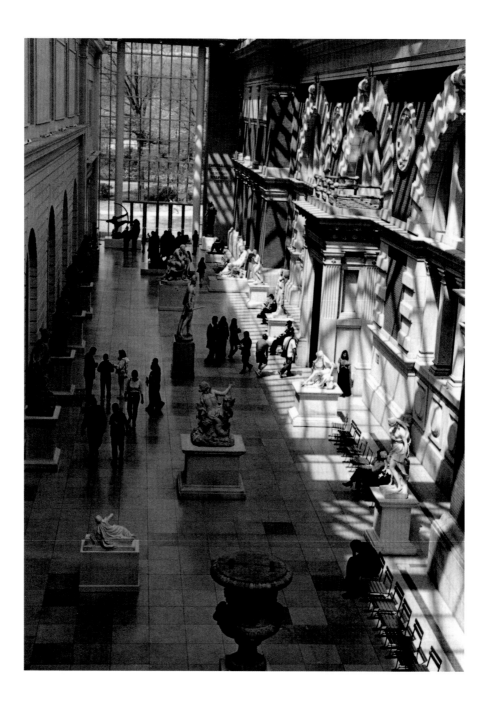

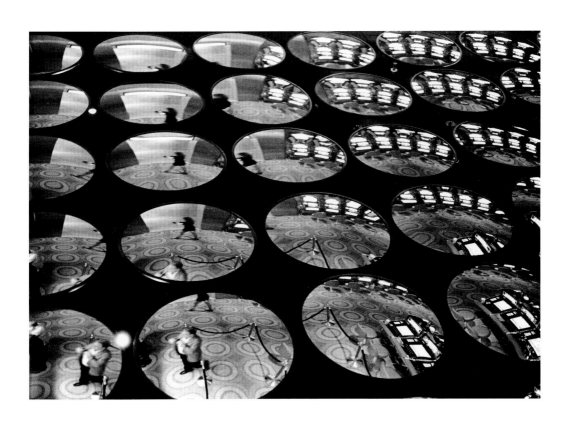

I dreamed a dream of
The sun, moon and stars

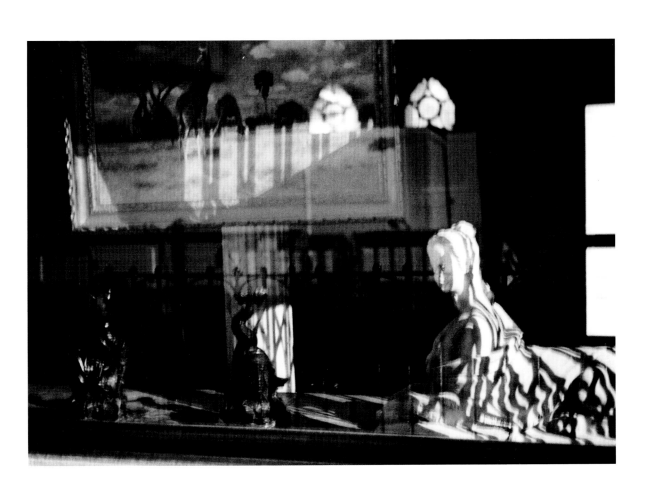

Always there
I dreamed a dream of you

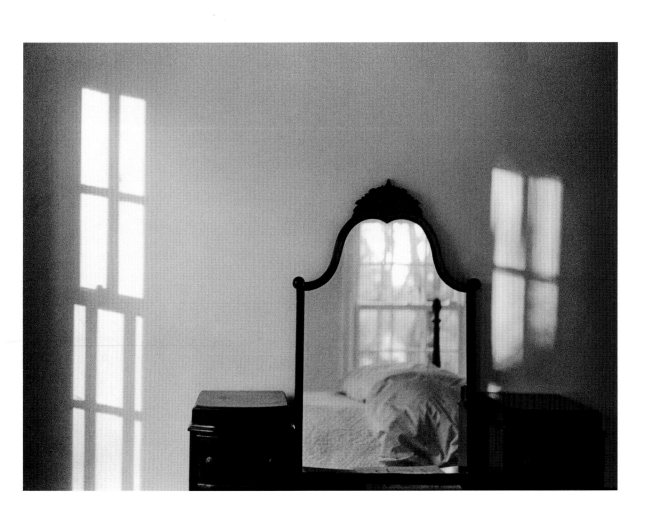

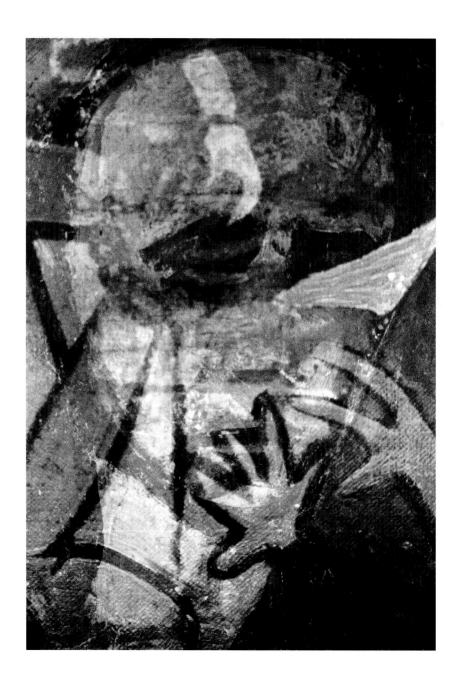

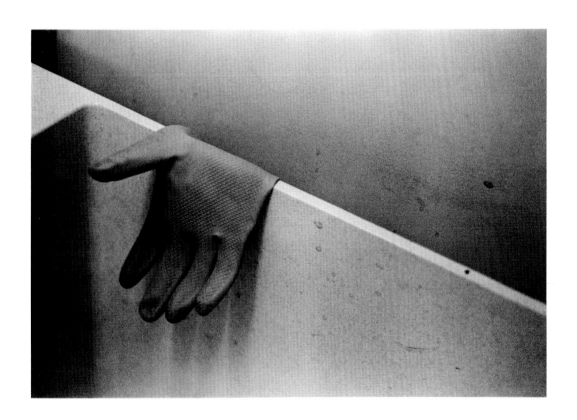

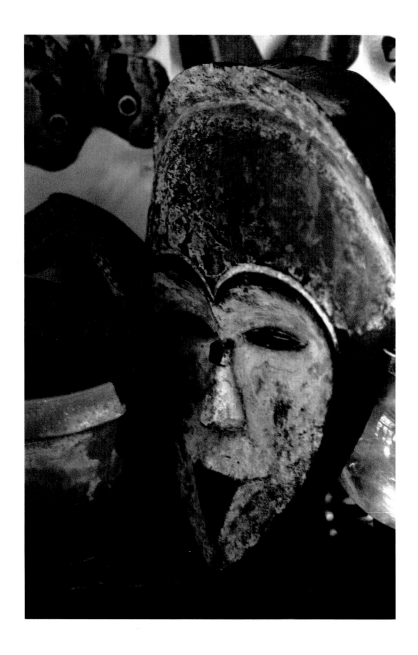

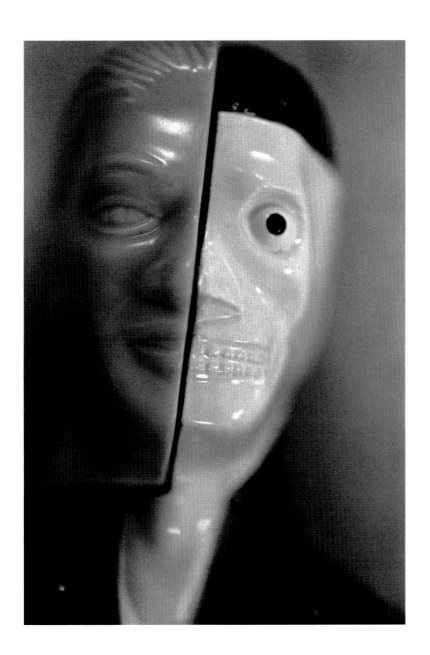

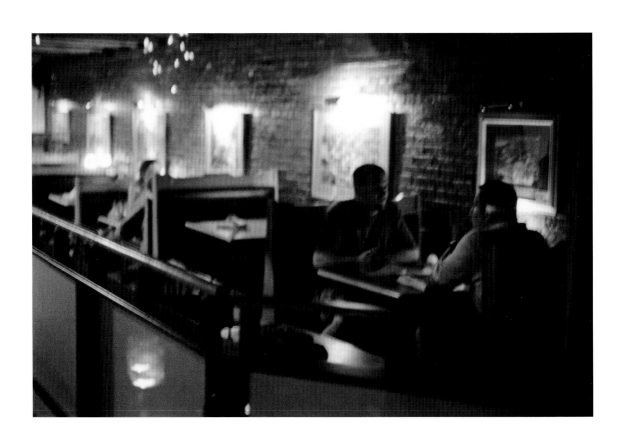

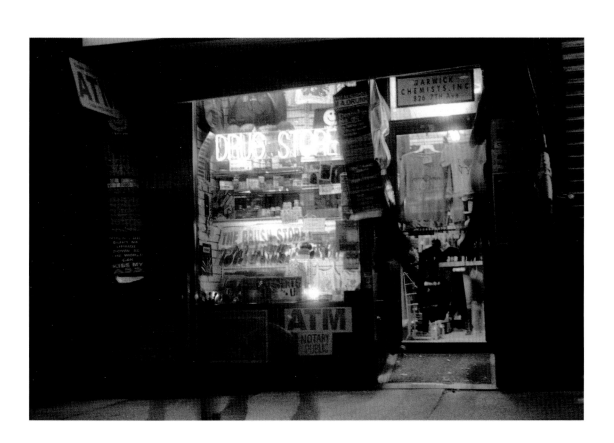

Night following day ends the dream

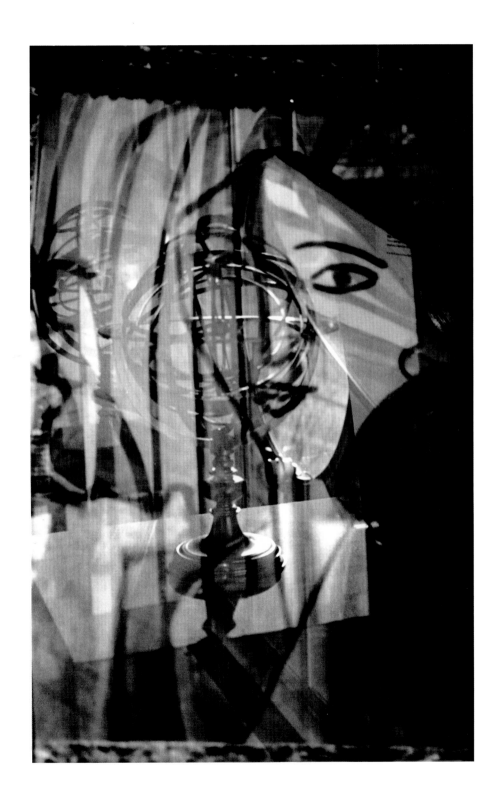

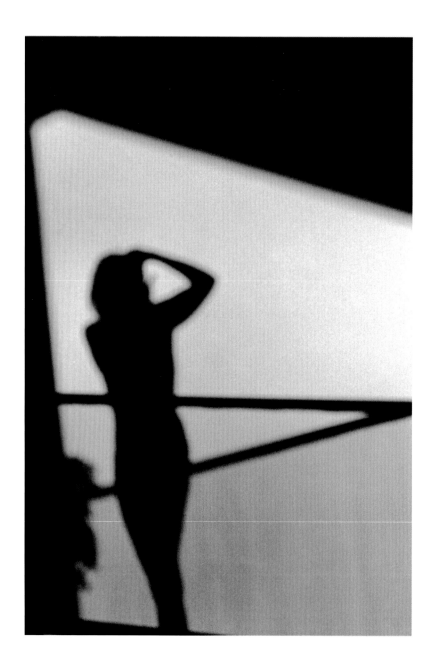

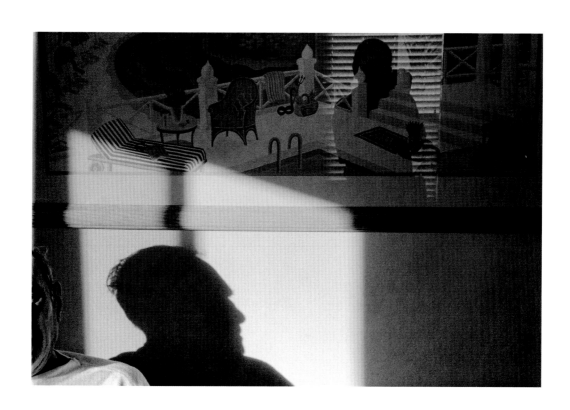

Light fades as memories do

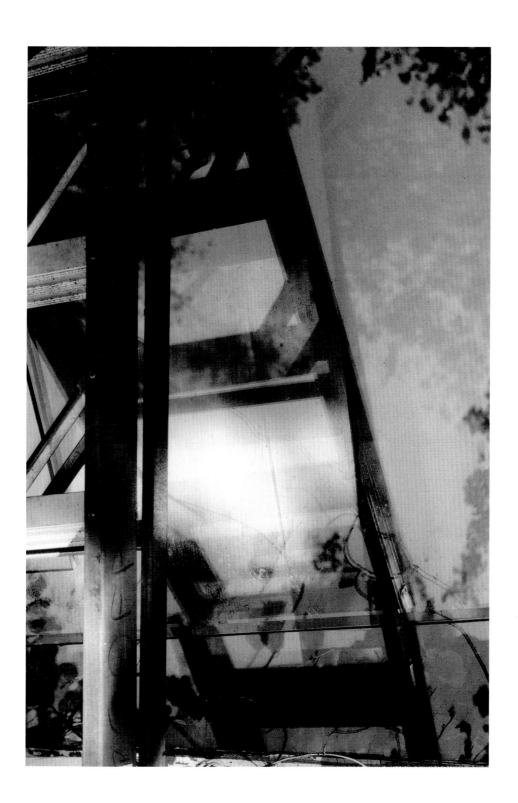

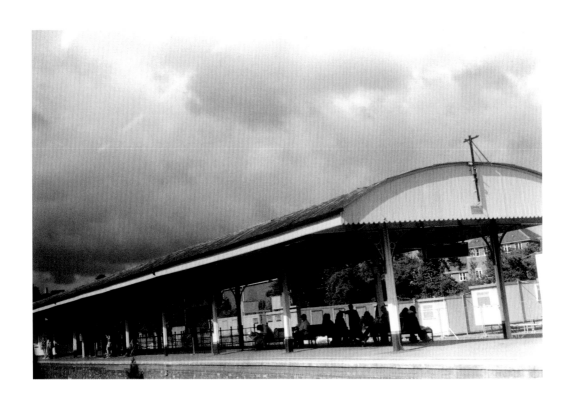

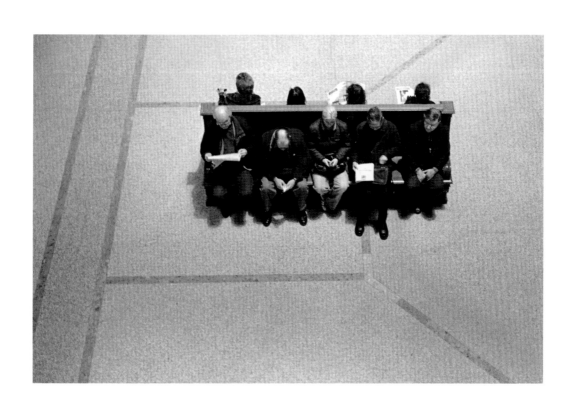

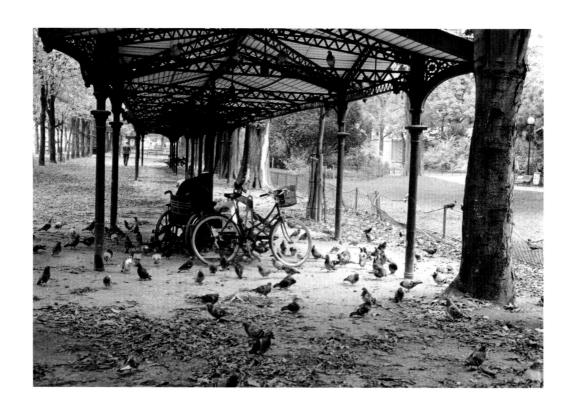

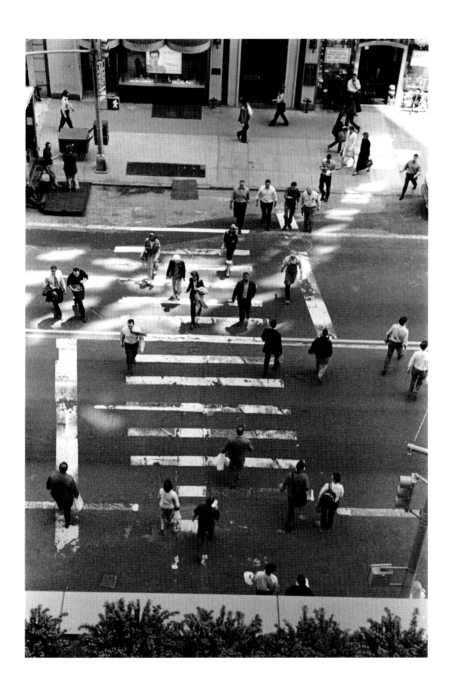

Loss is forever
A continuous absence
Of a presence,
Except when we remember

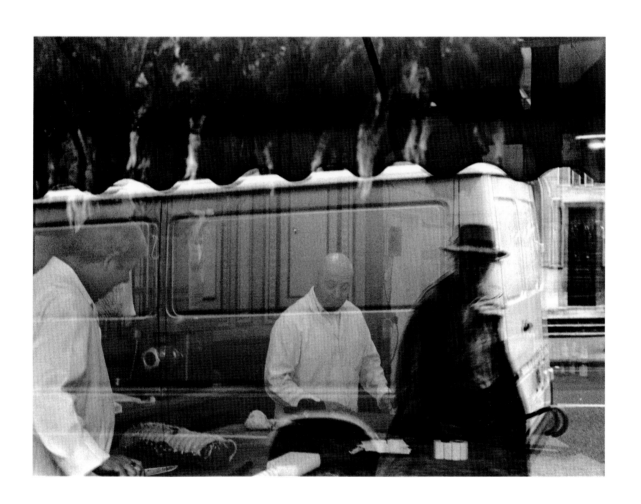

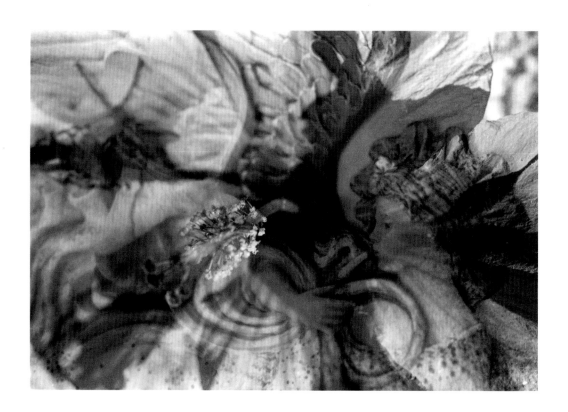

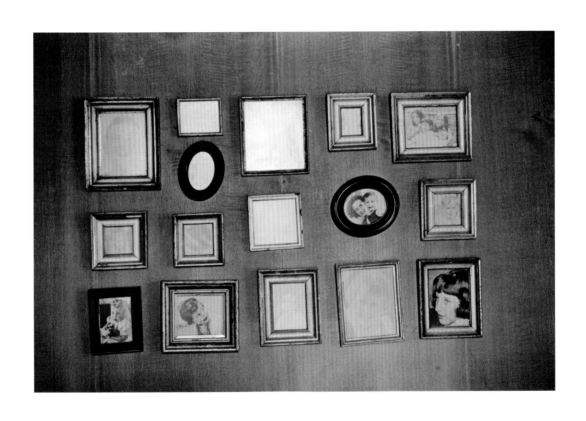

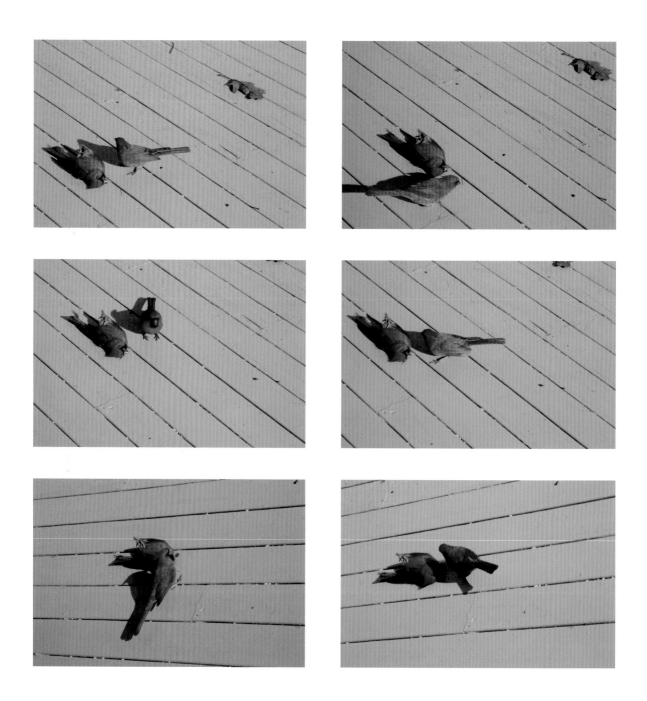

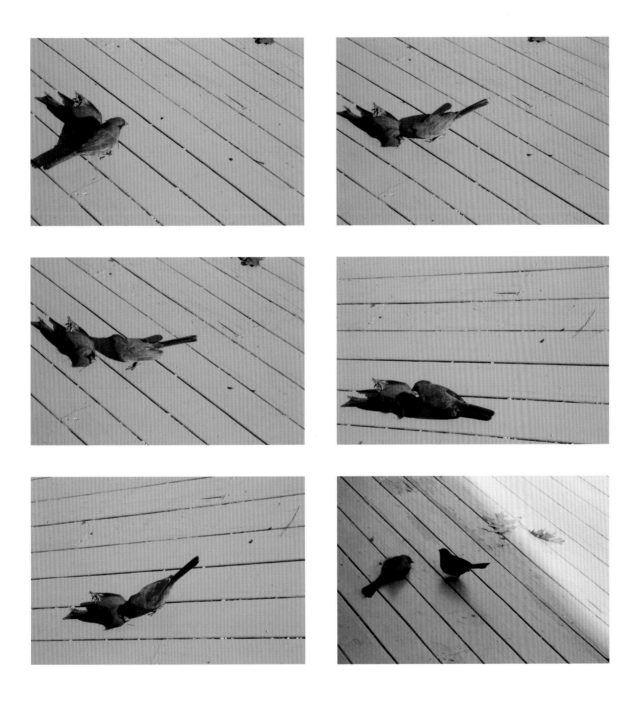

Someone to remember us
Is our prayer

We are leaves fluttering
Clinging to branches
Before falling

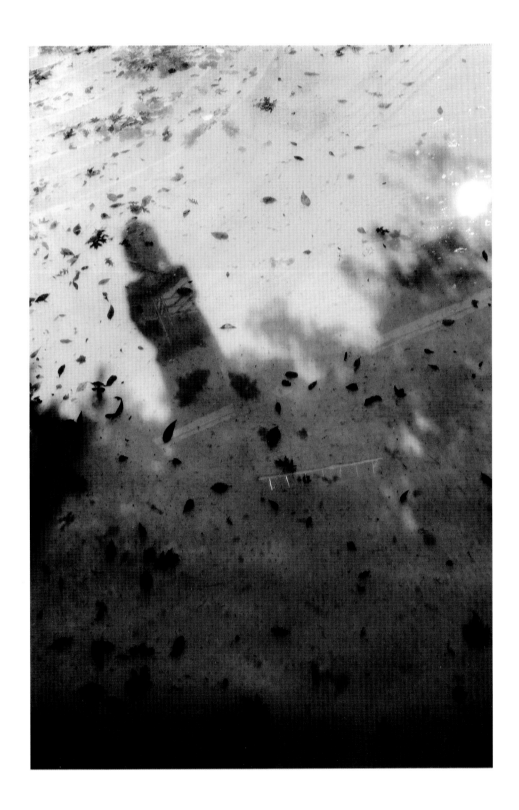

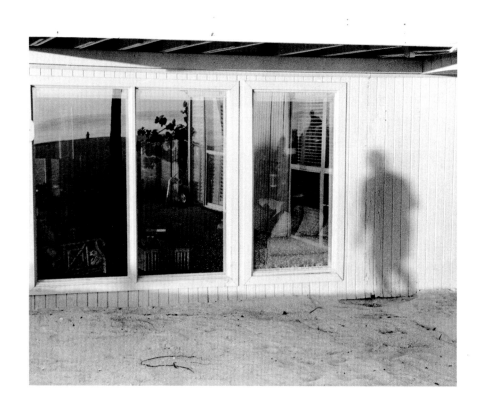

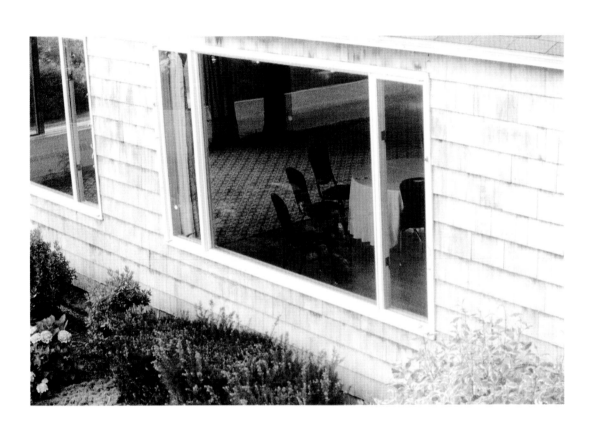

I dreamed a dream

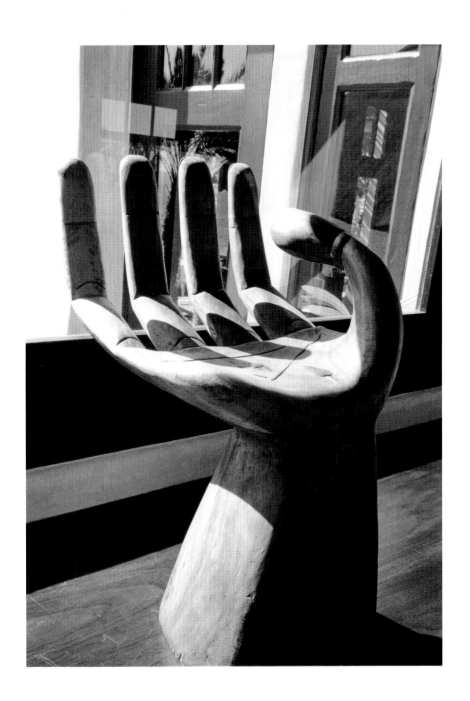

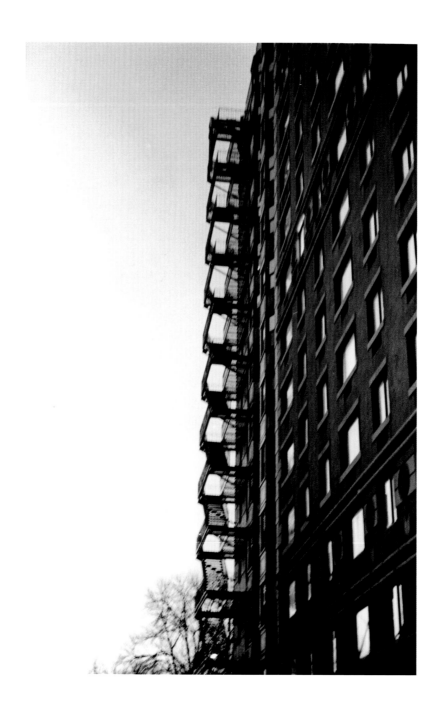

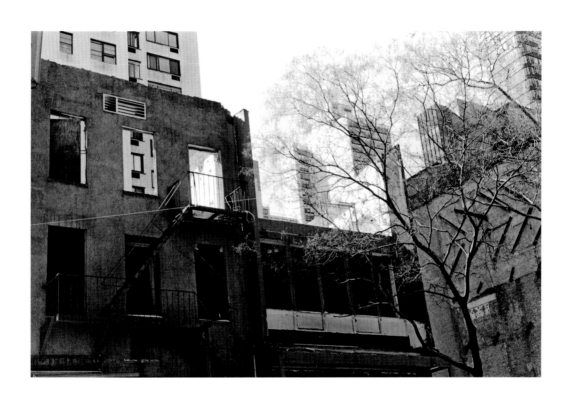

I asked, where are you?

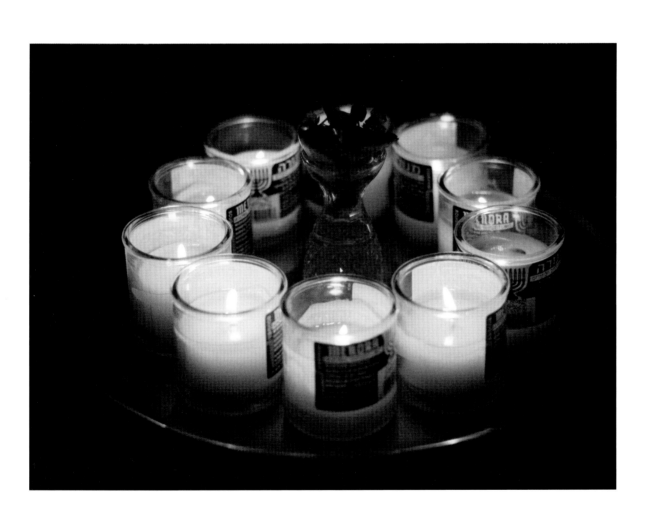

You are no longer here
When I need you most
I ask, why did you leave me?

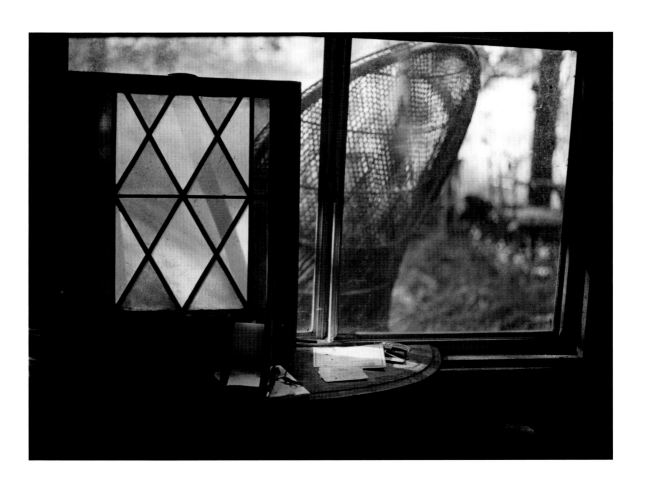

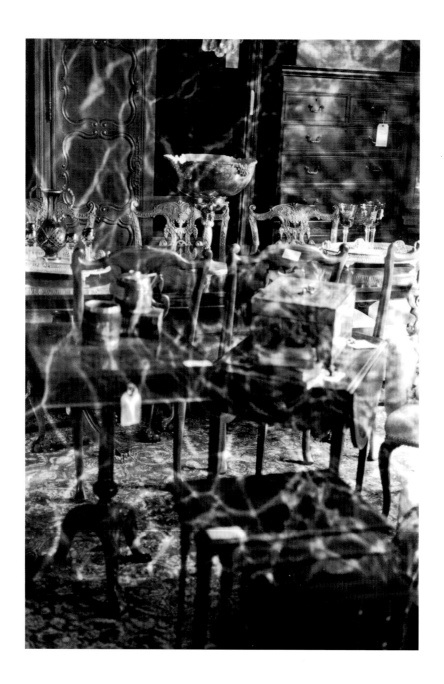

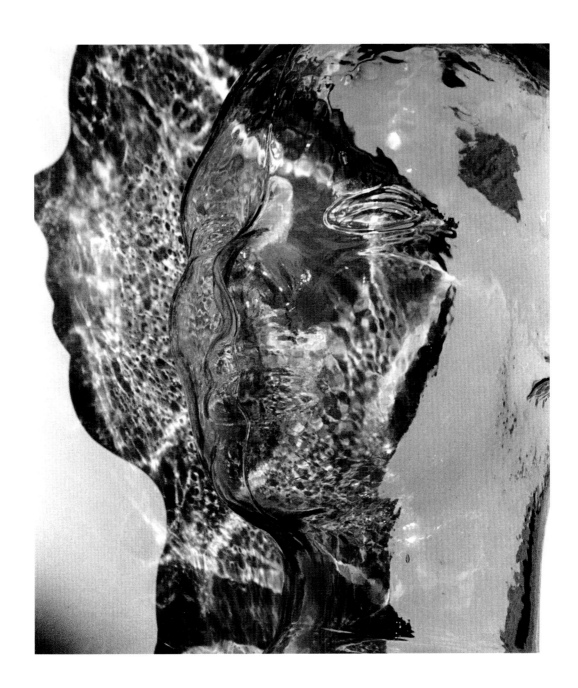

I ask, why did you leave
When I have loved you so?
You are missing beautiful days
Sun shining
Crisp air

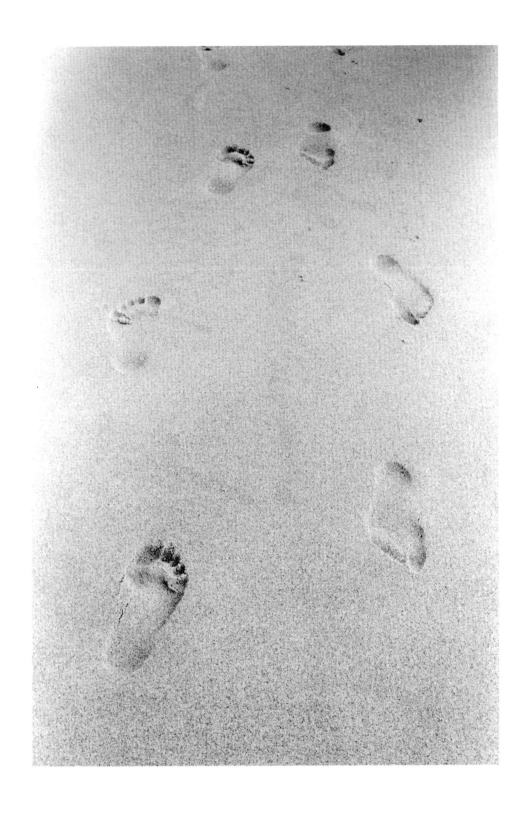

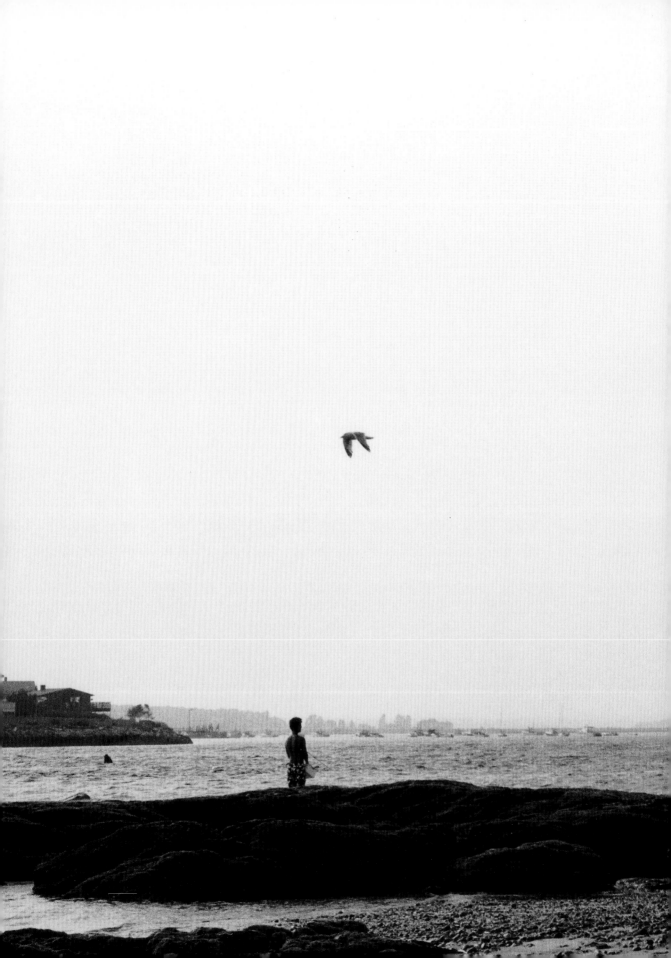

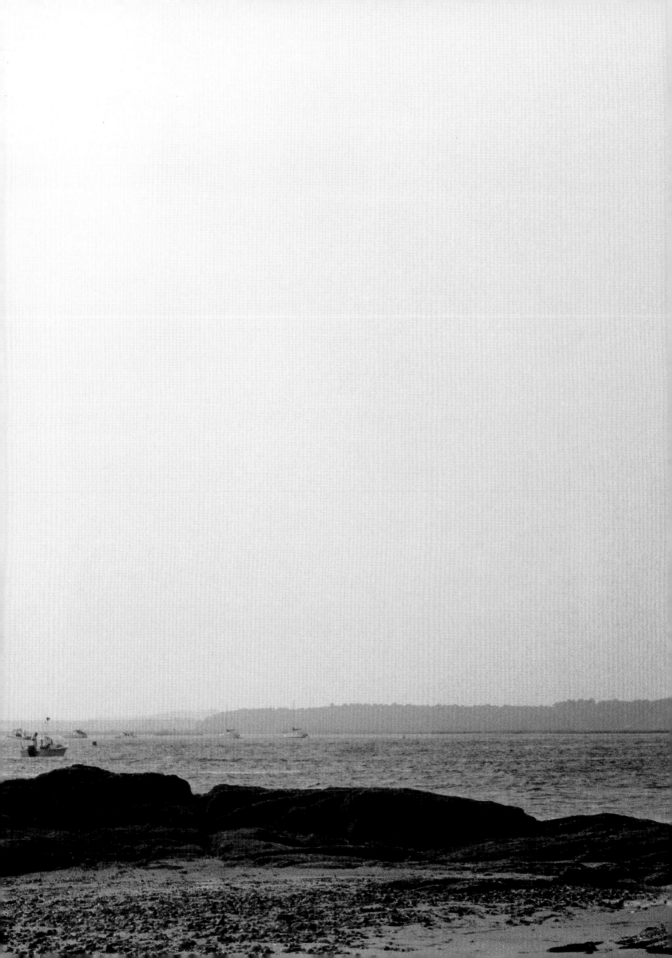

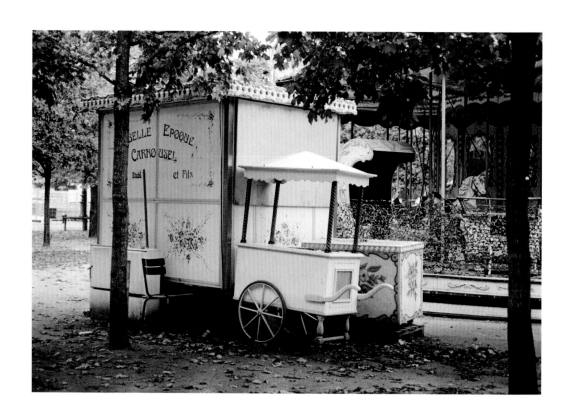

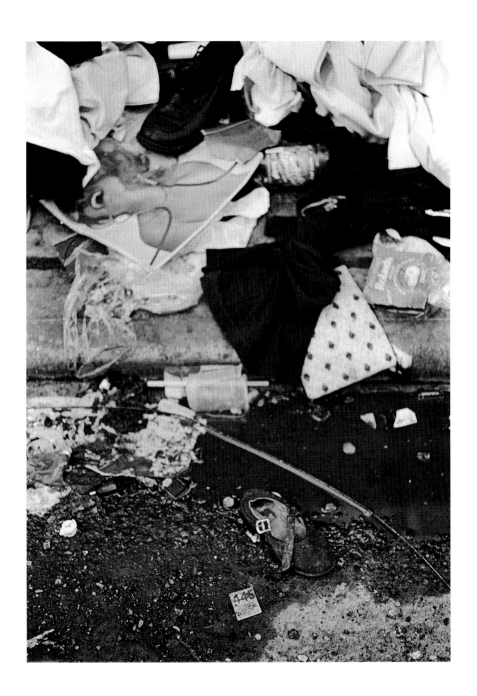

Summer has gone
So did you

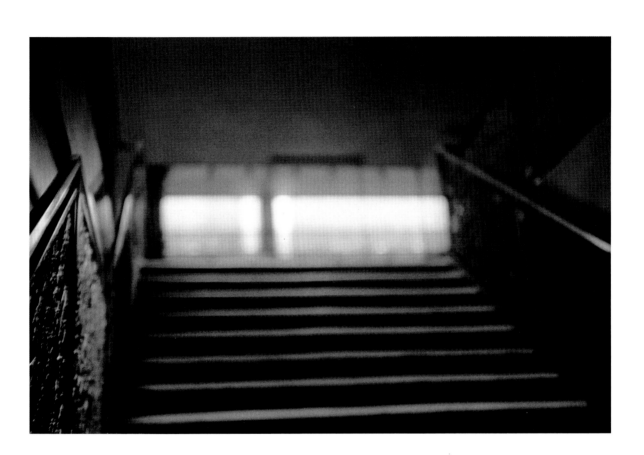

You were my friend
I dream of you
You are not here

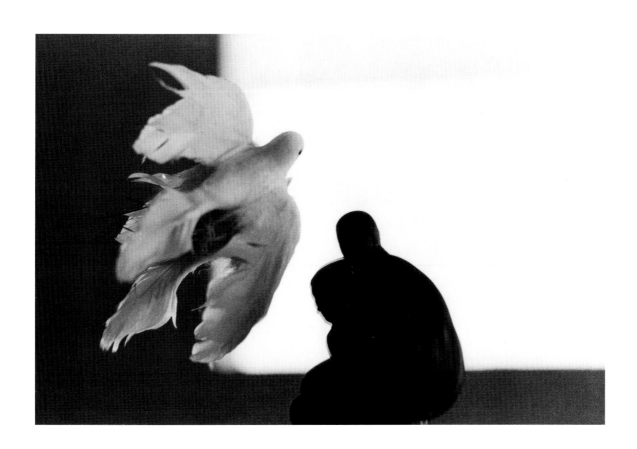

I wake
Troubled by your visit
Trying hard to remember

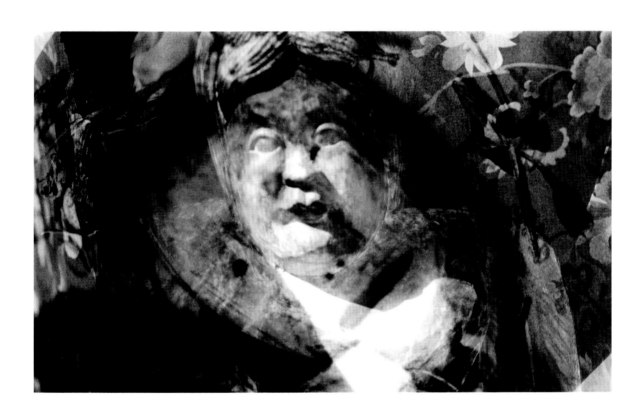

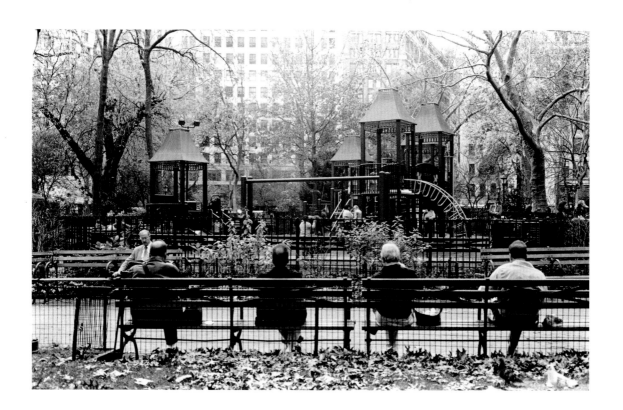

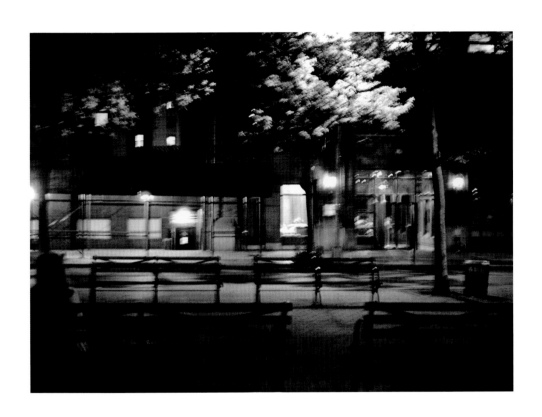

Why you came
What did you say
What did we do

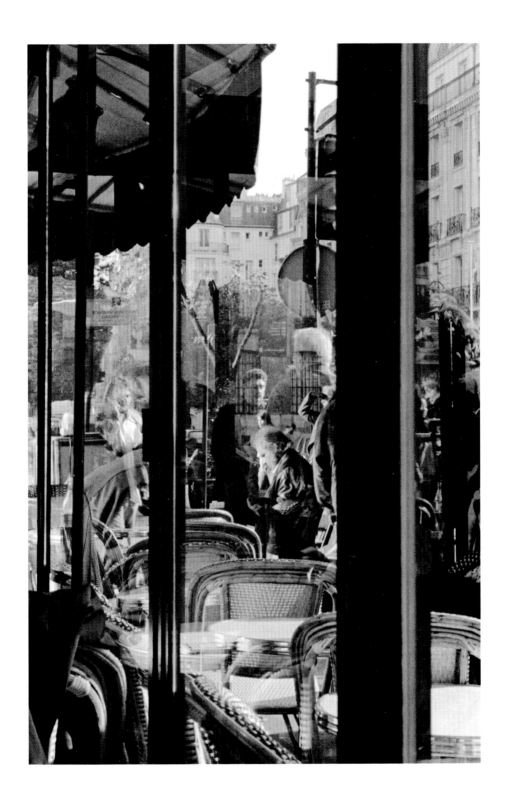

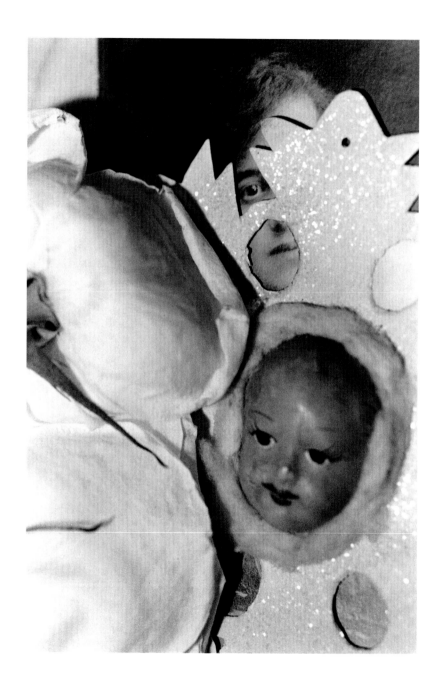

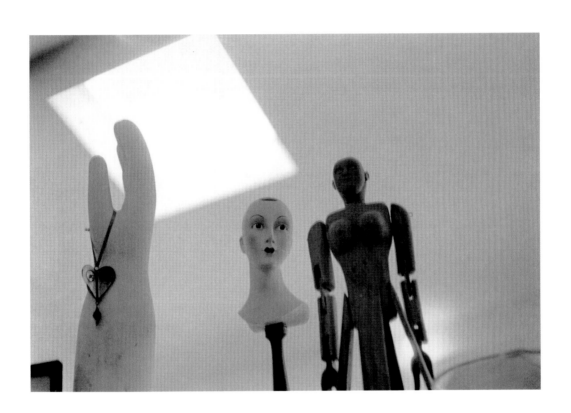

Morning arrives
You disappear again

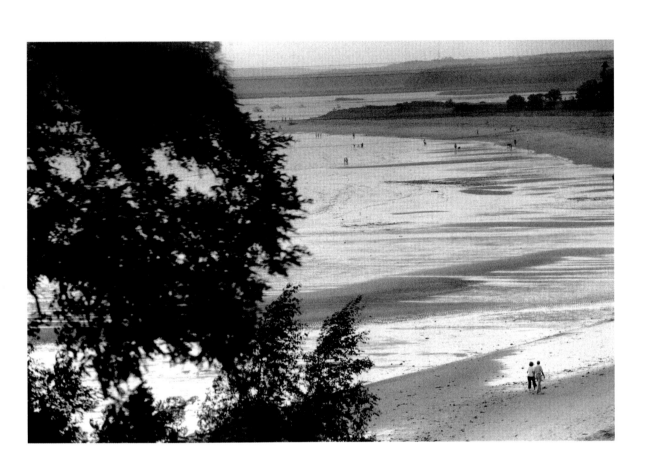

I try to keep you with me
You leave

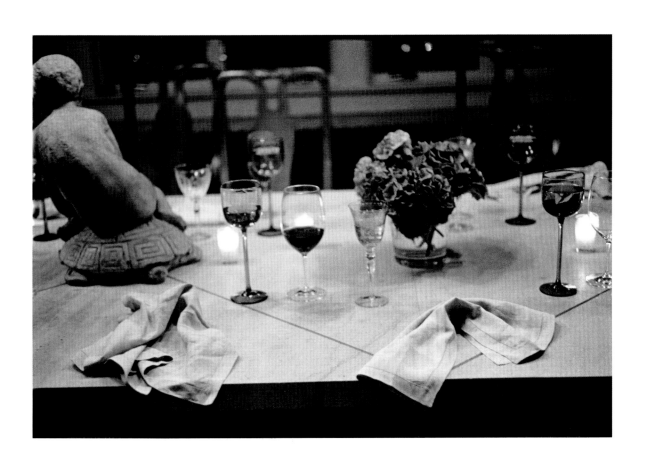

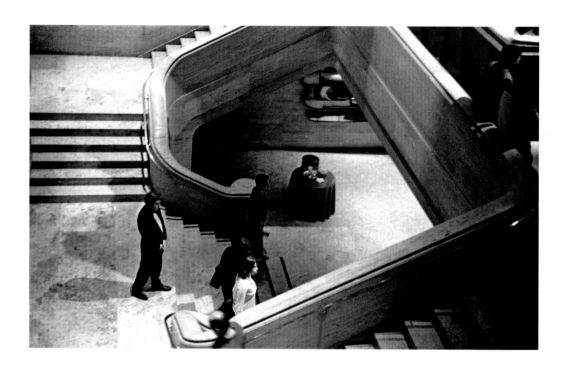

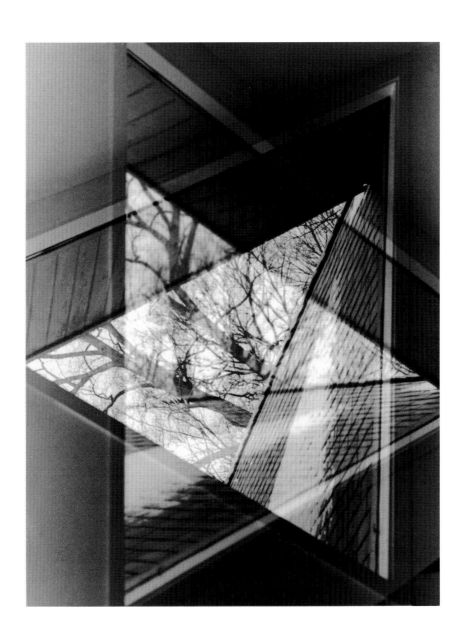

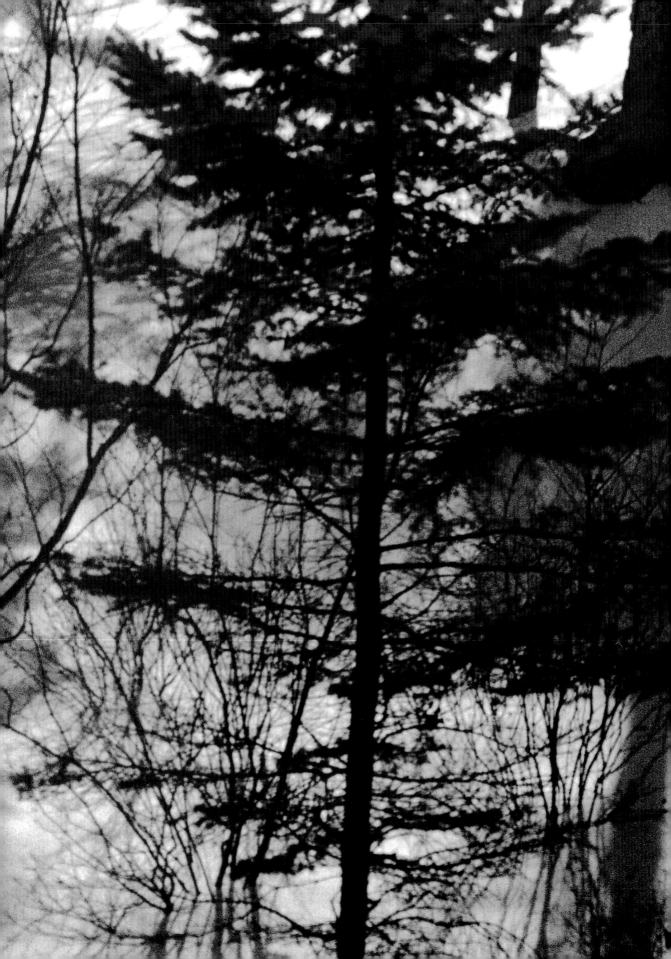

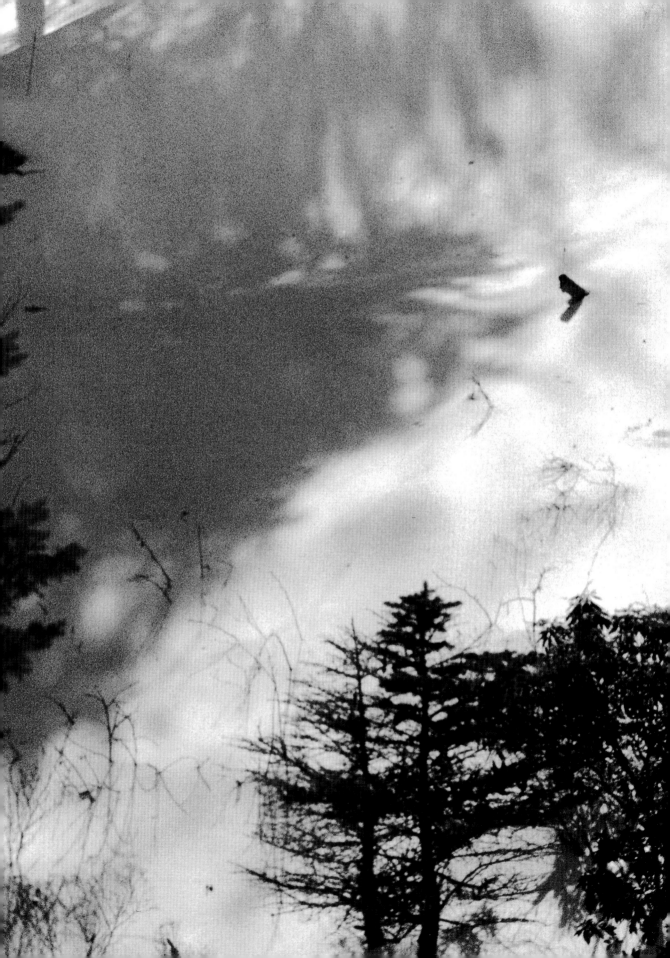

I want you to see the beautiful day
I want you to call me
You are not here

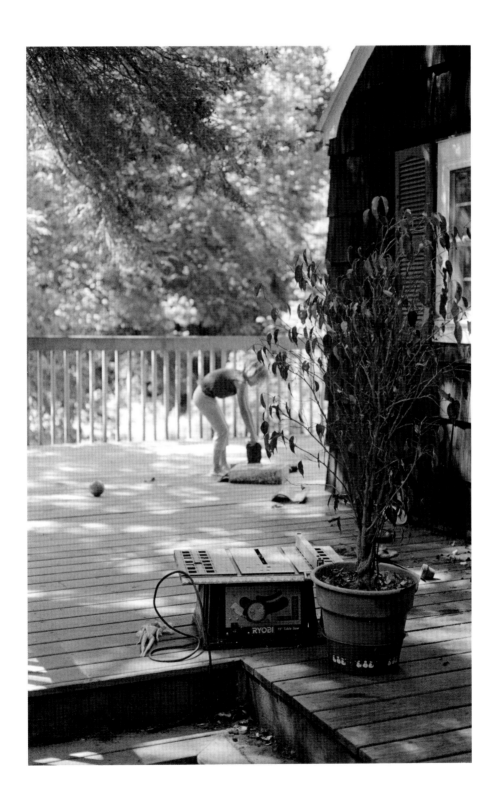

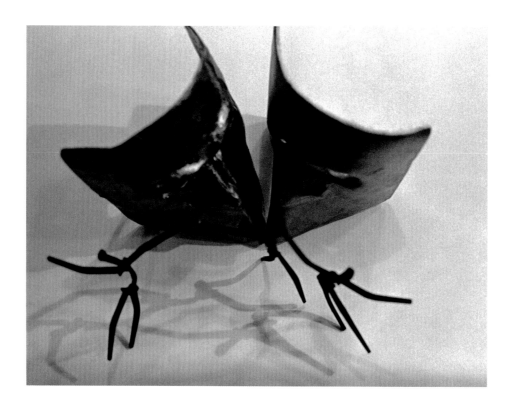

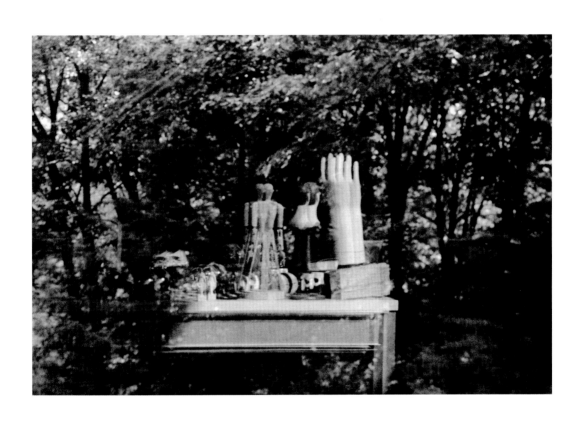

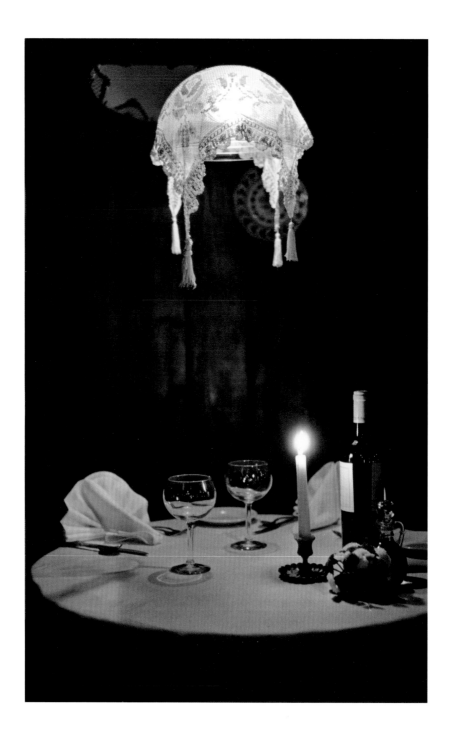

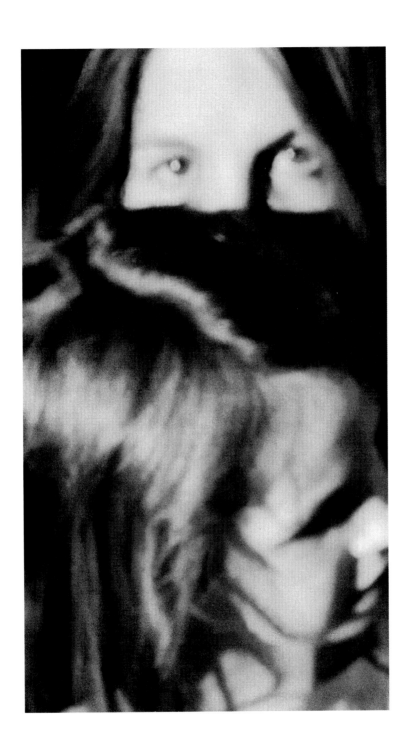

I wait for night
Will dreams bring you back to me?

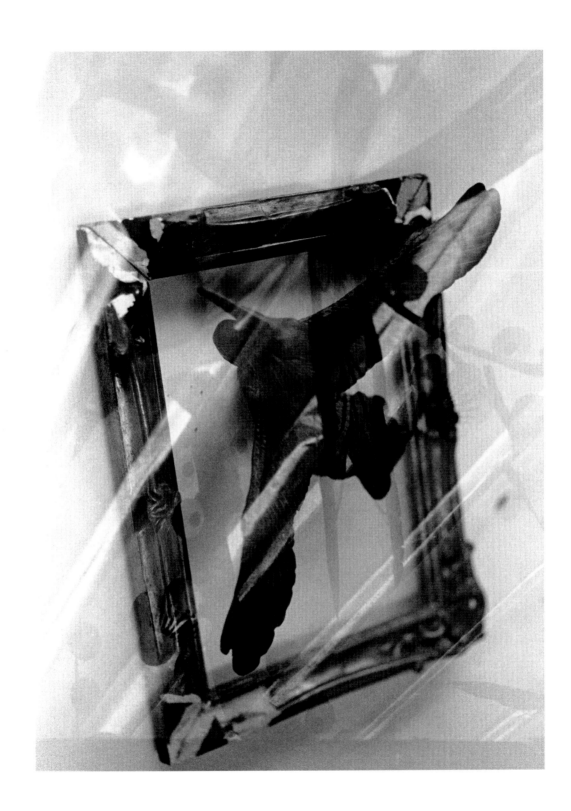

I dreamed a dream
You are no longer here.

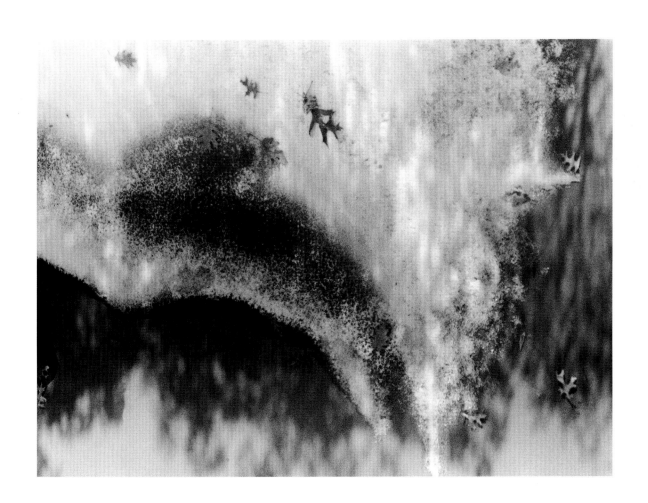

DIVERTISSEMENT
...I Dreamed a Dream

by Claire Yaffa

I dreamed a dream
Two rings
Fell from my hands
Breaking apart
Gathering pieces
To be together again

I dreamed a dream
I saw the moon
The moon saw me
I made a wish on the moon
I closed my eyes
I disappeared with the moon
Behind the clouds

I dreamed a dream of
The sun, moon and stars
Always there
I dreamed a dream of you

Night following day ends the dream
Light fades as memories do
Loss is forever
A continuous absence
Of a presence,
Except when we remember

Someone to remember us
Is our prayer
We are leaves fluttering
Clinging to branches
Before falling

I dreamed a dream
I asked, where are you?

You are no longer here
When I need you most
I ask, why did you leave me?

You are missing beautiful days
Sun shining
Crisp air
Summer has gone
So did you
I ask, why did you leave
When I have loved you so?
You were my friend
I dream of you
You are not here
I wake
Troubled by your visit
Trying hard to remember
Why you came
What did you say
What did we do

Morning arrives
You disappear again
I try to keep you with me
You leave

I want you to see the beautiful day
I want you to call me
You are not here
I wait for night
Will dreams bring you back to me?

I dreamed a dream
You are no longer here.

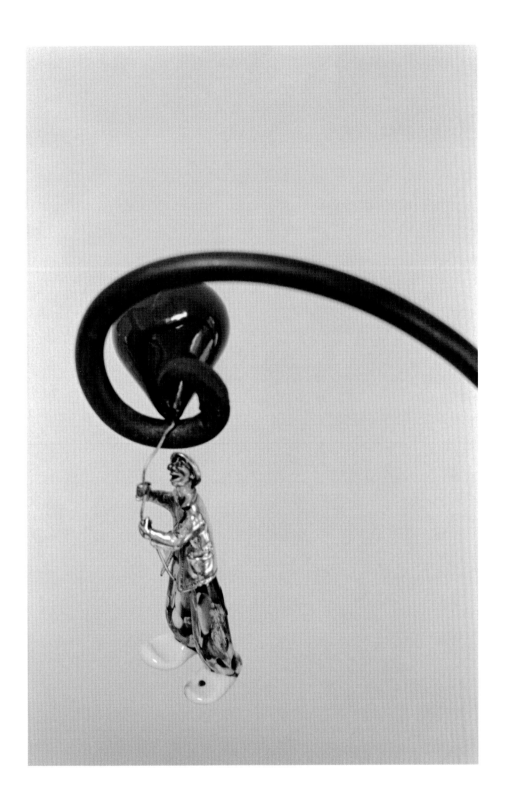

List of plates

Exhibitions

Leica and Other Photographers
Ongoing project

The Human Face of the Homeless
Ongoing project

Claire Yaffa: A Retrospective and new work
Leica Gallery, New York City
June 2008

Foster children for adoption
Heart Gallery, 2007

Personal Visions:
What We Photograph and Why
Panel discussion and exhibition
Sarah Lawrence College, 2007

Harrison Mosaic:
Residents of Harrison, New York
Town Hall, Harrison, New York
Permanent Collection
The Harrison Historical Society, 2007

The Human Face of Homeless
Mount Hope A.M.E. Zion Church
White Plains, New York, 2007

The Human Face of Homeless
Y.W.C.A.
White Plains, New York, 2007

Obscura Gallery,
Denver, CO
2007
Life's Dream and Other Photographs
Exhibition

Aperture at 50: Photography Past/Forward
2006
Group exhibition/traveling exhibition

Katonah Museum: Hot Pics
2006
Juried exhibition

The Vincent J. Fontana Center
for the Prevention of Child Abuse
New York, NY
2005
Permanent collection

Chelsea Art Museum, New York, NY
December 2003
Celebration of Women
Group exhibition [Publication, Assouline]

Fait et Cause, Paris, France
June 2002
Life & Death Once Upon A Time: Children with AIDS

Simon Wiesenthal Center
@ Art Director's Club, New York, NY
1999
Who Will Remember?
Holocaust survivors, rescuers, hidden children

Office of the Westchester County Executive,
White Plains, NY
December 1998
Homeless children

Rye Art Center, Rye, NY
October 1998
Through The Lens
Juried exhibition of Westchester artists

International Center of Photography,
New York, NY
September 1998
Light and Shadow

Camera Obscura Gallery, Denver, CO
August 1998
Light and Shadow

Neuberger Museum, Harrison, NY
December 1996
Children with AIDS
Lecture and exhibition

Neuberger Museum, Harrison, NY
Summer 1996
Harrison Mosaic: Portraits of Citizens Living in Harrison,
New York
Lecture and exhibition

Cleveland Museum of Health and Science,
Cleveland, OH
June-August 1995
Children with Aids: An Endangered Species

Rockland Center for Holocaust Studies, Inc.
Spring Valley, NY
1994
Who Will Remember?

Sarah Lawrence College, Bronxville, NY
1993
Children With Aids: An Endangered Species

Camera Obscura Gallery, Denver, CO
1992
A Dying Child is Born: The Story of Tracy

Katonah Museum, Katonah, NY
1992
The Concerned Artist
Juried exhibition

The Bridge Gallery, White Plains, NY
1992
*Remembering Together: Photodocumentary
of Survivors Rescuers and Hidden Children
of the Holocaust*

The Bridge Gallery, White Plains, NY
1992
Making A Difference
Portraits of homeless children and
families at summer camp

Nardin Gallery, Katonah, NY
1992
Juried show

Hiram Halle Memorial Library, Pound Ridge,NY
1992
A Dying Child is Born: The Story of Tracy

Nikon House, New York, NY
1991
A Photographic Mosaic
Juried exhibition

Sarah Lawrence College, Bronxville, NY
1990
Discovery: A Continuing Journey

New York Foundling Hospital, New York, NY
1989 to present
Permanent collection, lobby

American Academy of Pediatrics, Chicago, IL
1989 to present
Portraits of Children
Permanent collection

The Bridge Gallery, White Plains, NY
1988
Homeless in Westchester County

The White Plains Museum Gallery, White Plains, NY
1988
Homeless in Westchester County

The International Center of Photography,
New York, NY
1987
Reaching Out
The problems of child abuse and rehabilitation

Sarah Lawrence College, Bronxville, NY
1987
Our World, Photographs of Children

Harrison Public Library, Harrison, NY
1982
The Story of A Life, Mrs. Mosher

The United Nations, New York, NY
1979
The International Year of The Child
Exhibition and poster

White Plains Museum Gallery, White Plains, NY
1979
The Child
For 'The International Year of the Child'

The Hudson River Museum, Yonkers, NY
1977
*The Blue Hammer: Portraits of Children at
LeakeWatts Children's Home*
One woman exhibition

Mexico
1975
International Year of the Woman Conference
Poster and invitation

Harrison Public Library, Harrison, NY
1972
Portraits of Children

Ms. Yaffa's photographs have appeared in *The New
York Times, Food Patch, Woman's News, Vogue,
The Wag, Vanity Fair, Daily News, Newsday, NBC
News, ABC News.*

She was the recipient of the 1995 Council for The Arts
Award for "Outstanding Artist in Westchester County."

Publications

Divertissement
Ruder Finn Press
2008

*LEICA Photographers
and others*
Exhibition and Book,
in progress
2007

Life's Dream
Ruder Finn Press
2007

The Human Face of the Homeless
Exhibition and Forum
2007

Moments
Ruder Finn Press
2005

*Embracing the Past:
"The Elders Speak"*
[On aging]
2004

*History of The New York
Foundling Hospital*
2001

Light and Shadow
APERTURE
1998

*A Dying Child is Born:
The Story of Tracy*
1990

Reaching Out
[The problems of
child abuse and rehabilitation]
1987

Homeless in Westchester County
1988

Biography

B.A. Sarah Lawrence College
1962

Research Technician
Memorial Sloan Kettering Hospital
1959-1966

Emergency Medical Technician and
one of the founders of the
Harrison Volunteer Ambulance Corps
1983-1988

Photographic studies with:
Fred Picker, Lisette Model, Phillipe Halsman,
Ben Fernandez, W. Eugene Smith,
George Tice, Eva Rubinstein, Joseph Schneider,
Sean Kernan, Ralph Gibson,
Duane Michals, Cornell Capa, Gordon Parks

Photo Editor
Westchester Magazine
1977- 1987

Chairperson
Breadth of Vision, Fashion Institute of Technology, NY
1975
[Largest juried exhibition of women's photography in
the United States]

Photography Coordinator
United Nations, NY
The International Woman's Arts Festival 1974